How to Notice

How

to

Expand Your Experience of Everyday Life

Notice

Melissa A. Butler

Book cover and interior design by Nick Caruso
Cover and interior photos by Matt Dayak
Interior illustrations by Nicholas Hohman
Author photo by Katie Long

The book was typeset in Kepler & Neutraface

Library of Congress Control Number: 2021918358

ISBN 978-1-7372578-0-6 (paperback)
ISBN 978-1-7372578-1-3 (e-book)

Published by
Notice-to-Wonder Books
Pittsburgh, PA, USA
books.noticetowonder.com

To all the small things

TABLE OF CONTENTS

LOOP ONE

LOOP TWO

LOOP THREE

LOOP FOUR

LOOP FIVE

INTRODUCTION

This is a book about how to notice.

I wrote it because noticing is a gift meant to be shared with others and practiced widely. Noticing has taught me things beyond what I can explain as understandings and noticing lets me live my life beyond my wildest dreams. I am grateful to be able to share this book with you. I wish you delight in this simple and joyful practice of noticing.

What is noticing?

Noticing is a practice that, through practice, becomes a way of being. To notice is to find what's there, what's not there, what may have been there before, what might be dreamed there. Noticing is more than a process of looking closely, it's a process of getting into the skin of what's being noticed. Seeing beyond what's there. Seeing into one's own seeing, thinking, and feeling about noticing itself.

You likely hear the word "notice" a lot. It's used in a range of ways—from a straight-forward meaning of "look," to more comprehensive meanings for "deep observation and assessment," to more philosophical and spiritual meanings around "awareness of consciousness and being." Part of a noticing practice includes the noticing of noticing—its definitions, applications, layers, and especially your own listening for where you hear "noticing" show up in the world and how you embrace it in your own life.

Why notice?

Noticing allows you to find out more about who you are in relation to how you see and understand things. It helps you become more of yourself and allows you to connect with other beings from a place of trust. It invites you into new layers of beauty and appreciation.

Why *you* notice will be particular to you. You may be curious about noticing. You may yearn to slow down. You may want to experience more presence and delight in everyday moments with ordinary things. Regardless of your initial motivations for noticing, when you practice how to notice with more nuance and depth, your overall way of being shifts, and new opportunities emerge throughout your life.

Whether noticing is new for you or at the core of your life, the moments of practice in this book invite you to expand your noticing and explore more about who, why, and how you are in the world.

How do we notice?

This book explores one method for learning how to notice, a practice for noticing small things. You'll be guided to practice how to notice through a series of small steps (moments) that you can do

inside your life as it is right now. You don't need to go on a retreat or have extra time in your day. You don't need to step outside of your life in order to practice. The most powerful noticing is practiced inside the everyday moments of everyday life with ordinary small things.

What kinds of small things?

For the purpose of this book, we will focus on noticing small found objects. Objects that can fit in the palm of your hand. Modest, ordinary things often tossed away or lost from view: piece of thread, twist tie, button, bit of crumpled paper, fuzz, screw. Or small fragments of nature: seed, stem, leaf, stone, shell. You may discover such objects outside or in your home. They may have been around for a while (hidden or unseen) or they may come into your life when you start reading this book.

You may be drawn to other kinds of small things—words in a poem, characters in a story, subjects in a painting, sounds, tastes, rhythms, shadows. You can play with these small things too, but for the practices in this book you'll also want to explore small things you can touch and hold in your hand.

Why small objects?

Small objects are everything. They are abundantly available, can be touched for tangible, physical noticing, connect to memory-dream-story, ground us in our ideas and experiences of daily life, and are easily lost-found and held-stored-carried. Small objects matter because they have an immensity of energy in their matter.

Objects are alive, as nature is alive. As humans, we are part of nature and we are part of the energy of all matter. Small objects allow us to connect with this energy, be curious about it, and explore more about ourselves in the process. Please note: You don't need to believe that objects are alive to learn how to notice with them. It doesn't matter what you believe. Learning how to notice is a process beyond anything we might hold as "belief."

What you'll need

Throughout the book you'll be asked to try things out. The most important thing you'll need is a willingness to try, even if at first something seems silly or you don't understand it. In addition to your open, playful spirit, you'll also need a notebook or loose paper (unlined is best), a pencil or a pen, and maybe a small space (shelf, box, windowsill) where your small objects might like to rest. But don't worry about the space right now. It will appear for you in the process. And don't worry about your objects yet either. We'll get to that.

A note about pronouns

There are multiple pronouns to use in naming an object: she, he, it, they, ki, kin. I often talk with my objects as she/he/they and I deeply appreciate the spiritual scholarship of Robin Wall Kimmerer who suggests the words ki and kin as pronouns to talk

about non-human beings as a way to bring deeper awareness to our connectivity with the natural world. In conversations with my human friends, I often use a variety of pronouns as we play and create meanings together, and I value critical language practices and discussions.

In this book, I use "it" and "they" when a pronoun is needed in reference to a small object. I find that these pronouns sit softly and with ease, allowing themselves to be less noticed than the words around them, thus not interrupting the flow of language or meaning. In no way do I intend for the pronouns "it" or "they" to take away from the aliveness of any object.

When I write, "I found a button and now hold it in my hand," the word "it" allows more noticing space for the noun "button," allows a reader to focus on the aliveness of the button, its energy and being in the palm of a hand. All small objects hold energy in their matter, energy that is fully alive and matters in this world.

Is this book really for adults?

Yes, this is a book for adults. You may decide to share it with children in your life. Indeed, a practice for noticing also matters for children. But this book is for you. It is meant for you to read for yourself and practice for yourself. If you approach this book only as a way to help others practice, you'll deny the gift of noticing for yourself.

You deserve to notice. You deserve to imagine and play and talk to and delight with small objects. You are more than a role model for children or others. You are more than a parent, grandparent, neighbor, educator, or other care-giving adult.

Let yourself receive this gift of noticing practice for yourself. Once you receive it, it will be almost impossible *not* to share with others in your life. But it starts with you. Allow this.

Before you see it

It is a root
and it is a worm
and it is the rain.

It is a petal
and a wish
and a wonder why.

It is not of news
or knowing.
Nothing underneath
or standing still.

It is not what you think.

Sometimes a glimpse finds you.

MOMENTS OF PRACTICE

We will practice how to notice through a series of moments organized in loops.

There are five loops of four moments each, for a total of twenty moments. You might spend a week on each loop, or a month, or longer. I call each point of practice a *moment* because each one is designed for you to embrace for yourself, in the time you have, for whatever time it takes.

Although there is no set timeframe for the process, noticing is definitely not something to rush. The more time you allow to practice each moment, the more you will embody a practice of noticing deeply inside yourself. An embodied practice of noticing—one that you feel fully and integrate as your own—is what will produce the most surprising, delightful results in your life.

Focus on one loop at a time, one moment at a time, following the sequence shared here. It is best

not to jump ahead or jump around. You may find yourself wanting to go back and repeat moments. This is fine. This is why each set of four moments is called a loop—for repeated practice. I've included reflection questions after each loop to help you reflect on your practice and decide when you feel ready to move on to the next loop.

Please don't worry about doing it "right." There is no one right way. Trust that you'll find a flow that's right for you. Trust that you'll receive gifts from this practice that are right for you, too. At its core, noticing is about trust and allowing.

Once you have some practice with the twenty moments in this sequence, you'll likely start to invent your own kinds of moments or create your own sequences—this is, after all, a playful process. But for now, allow yourself to go slowly and fully experience each moment of guided noticing practice shared with you here.

Let's begin.

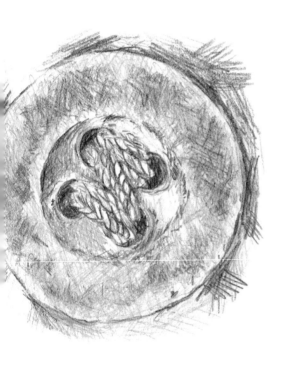

Loop One

Find · Receive · Shift · Be

Find

Anything
we find
was already
here.

It's time for you to find a small object or two. Are you ready?

This is less about searching and more about allowing surprise. There's no need to rummage through your drawers or peer under couch cushions. You don't need to do much. Objects like to be found. And they like to have a say in how they are found. In a way, an object is found *by* you at the same moment the object *finds* you.

When I spy an object on the ground and am drawn to pick it up, I often say, "Ahh, thank you for finding me!" Everyone is different, though, so you don't need to be like me. You might find objects in ways I know nothing about. (I can't wait to hear how you do it.)

To start your practice of *Find*, simply say out loud, "I would love to find a small object perfect for me." Maybe close your eyes. Feel the joy of what it might feel like to hold a small object in your hand.

That's it. Then go about your day and don't think too much about objects.

It is very important that you don't over-think this or picture any specific object you "want." You can't find your perfect object this way. It will feel too bossed around and won't want to find you. You need to trust that you will meet your perfect object at the right time.

If, after a few days, you haven't been delighted by a small found object, find a quiet place to sit, close your eyes, and repeat your wish out loud again: "Oh, I would love to be surprised by a perfect small object just for me." Remember, this is about *feeling* the delight of finding rather than thinking about it.

Receive

A small object is a gift. Receive it fully.

When you first find an object, inside that moment of surprise—warm flood of energy, "Oh, hello, it's nice to meet you!"—this is the perfect time to practice *Receive*. Later when you remember the object in your pocket or see it again on a shelf, you can appreciate it, but the appreciation that's part of receiving is best practiced on first meeting.

When you first spy an object, let yourself be present. Don't worry about time or where you're going. It's you and the object. Allow yourself to feel *into* the finding—you have found a special gift and shared yourself in a way that let you be found, too. Open your heart and allow yourself to fully receive this. Be present for as long as you can. Allow delight to emerge and expand. This object may be small, but it is grand. Marvel at it, and with it.

Your brain may try to classify the object when it sees it (paperclip, piece of metal, bread tag). Try your best not to do this. Objects, especially those who have been "lost" for a while, don't like

to be labeled; they are hoping for a chance to be found as something new.

This moment of receiving may last five seconds as you spy an object, bend to pick it up, and receive it as you continue walking. Or, you might find yourself standing somewhere for a few minutes in awe of the moment while you are inside it. I once found a 3-centimeter-wide, blue, plastic octopus under leaves and dirt in a sidewalk crack. I have no idea how long I stood in shock and awe that this octopus appeared for me. I still can hardly believe it.

When you receive your object with open-hearted delight, you share joy back into the object and into the world.

Shift

You don't see the world as your object sees it.

What's slow to you may feel fast to your object. What's near to you may be far. What's quiet might be loud or what's loud might be quiet. What's small is most definitely big.

Your object needs to breathe and settle in. Imagine how you'd feel if a larger creature picked you up from where you were resting. Although it was easy for you to bend down or reach over to pick it up, imagine how startling it may have been for your object. You likely interrupted something that was happening that you couldn't see or hear or know.

To practice *Shift*, let yourself imagine what your object may be feeling right now. Feel into this. Close your eyes and feel the energy *of* your object and *around* your object. Wonder from your body and spirit as well as your mind.

Introduce yourself. Maybe say some kind, welcoming words. Show your appreciation for your object choosing *you*. Objects love a bit of formality with their whimsy.

You might ask your object if it has anything to say, but don't worry if it's silent at first. Sometimes it takes weeks (or months) for an object to open up. You might try to listen into the silence and be quiet with your object. Or you may sense that your object wants to hear more about you. I usually tell my objects about ordinary things like my cat or what I ate for breakfast, but you can talk about whatever feels right to you.

One thing to keep in mind is that objects always know if you're genuinely talking with them or just pretending. Let yourself be as vulnerable and authentic as you can with your new small friend.

Be

Allow yourself to be with an object without an agenda.

A practice of *Be*, rather than do, can be a challenge, especially if your object and your mind immediately ping-pong ideas together. Let yourself be. Let your object be. Breathe.

If your mind thinks of something to make or a new game to play with the object, maybe write it down in one of your notebooks, but don't act on it. Don't *do* anything with your object. Your object is not a means to an end or a piece of a newly imagined whole. Your object *is* the whole of itself and the whole of this moment.

You and your object need to get to know each other. Each object has a unique story of how it came to be and a unique journey of how it came to find you. You need time to wonder about this and listen.

That said, you don't need to think too hard or do anything special. You can keep your object in your pocket or put it on a shelf in the room where you are. As long as your object is somewhere near

you (for at least some time of the day), you and your object will be able to sense one another as you give each other space to be.

You might feel a fine-line edge between allowing your object to be and ignoring it. If you notice this edge, allow yourself to wonder about it. This is part of noticing, too.

The most important thing is to make sure you continue to bring awareness to your object—know that it is there. Trust that your object knows you're there, too.

Rest & Reflect

How was your practice of these four moments? Was one easier than the others? Was something a challenge for you? Reflect and wonder.

Have you talked with anyone about what you're practicing? What did they say? How did you respond? If you haven't told anyone about your practice, wonder about this.

What has surprised you most about your practice so far?

Do you feel like you are able to communicate (listen-share-be) with your object/s or does it feel like you're pretending somehow? Reflect on the word pretend. Maybe draw a Venn Diagram and wonder in the overlap between *pretend* and *not-pretend.*

Before moving on:

Allow yourself to find and receive a few objects. Get a sense of them. Allow them to meet each other. Perhaps they'll tell you where they like to rest. Give them time to get to know you. And give yourself time to get to know yourself as someone who finds and receives small objects with delight. That said, as long as you have met one small object, you have all you need to practice the next loop of moments. And, if you haven't been surprised by a "new" object yet, that's okay. This probably means you're over-thinking things. No worries. Simply pick up any small object around you, hold it, and say "hello."

Loop Two

Look · Stay · Play · Between

Look

Look closely, even closer. There's always more to find.

You've set a lovely stage for looking because you've taken time to find and receive, shift your lens, and allow space to be. Now you're ready to practice *Look*. A quiet place is best, but if you know how to stay quiet in your mind, any place will do.

Pick up and hold one of your small objects. Only one. Clear away anything else. Your object needs to be the center of your attention.

Begin to look with both touch and sight. If you want, you can separate these and focus only on touch and then only on sight. This can be interesting, but the rule of only *this* and only *that* can also feel rigid and distract from the ease and lightness of your looking. As long as you are present with your object, you will naturally create your own flow back and forth between touch and sight (smell, sound, maybe taste, maybe other senses), sometimes at the same time, sometimes with eyes closed, sometimes zooming in or out until your object blurs into nothingness.

Notice what you find in the object—subtleties of color, form, texture, size. You'll find surprises, too. Objects love to feel your joy from surprise. When you discover a surprise, keep alert for more. Surprises usually tumble out in bundles.

As you look, also notice what you find in yourself—subtleties of idea, emotion, memory, story. You might find surprises in yourself, too. Notice if these bring you delight or something else.

This is all you're doing now. You are looking at your object. You are noticing what you find as you look.

Stay

Invite, allow,
savor, sink,
dig-in, linger,
be still.

Return to the same object you noticed when you practiced how to *Look*. Hold the object in your hand. Clear away anything else. Remember what you noticed the last time you looked.

Reflect on your previous practice. Was it easy? Was it a challenge? Did you feel bored or want to be done? Did you focus more on the object or more on your thoughts and feelings? How long did you stay with your looking?

If it felt challenging for you to stay present with your looking, I recommend that you set a timer for this practice. Ten minutes. If you want to try for longer, go for it, but ten minutes is a good place to begin.

If staying present with your looking felt easy, reflect on why and find a place where you could find more challenge. Maybe set a timer for what seems like a stretch or set your awareness to focus on a particular aspect of looking that you didn't practice as much the first time (maybe you

noticed a lot about your object but avoided noticing yourself or visa versa).

Let yourself *Stay*—be present and look at your object. This is all you're doing. You are looking. You are letting yourself stay and look.

This doesn't need to be pleasant. It might not be at first. Your mind is good at getting busy and filling up spaces that feel too still or too empty. Your *Stay* practice may challenge you in ways that feel uncomfortable. Let this be. Your object won't judge you, so please don't judge yourself.

But do nudge yourself to stay with your looking just a little bit longer than you want to stay. This "little bit longer" will allow you to find some beautiful things.

Play

In, out,
up, down,
around,
flip, fall,
tumble—
allow it all.

Return again to the same object that you noticed for both *Look* and *Stay*. Don't worry about setting a timer or selecting a challenge this time. But do notice your thoughts and feelings along the way. You might want to jot some notes as you practice, but this isn't necessary.

Play is a word with a broad set of meanings. It's frequently used to describe games or having fun. But at its core, play is more than this. When we play, we are flexible in our thinking, we delight in mistakes and being wrong, we look for surprises, we listen to others and add generously to what they contribute (e.g., "yes, and..."), we are present in the here and now, and we allow our inner joyful spirit to shine.

With your object, try out a practice of *Play* in one or more of these ways:

1. Flex your thinking to see your object anew (turn your object different ways, move far away from it, look at it through different kinds of materials—clear, foggy, knit).

2. Try to be wrong and not-know your object ("I thought this was a _____, but maybe it's _____." or "I imagined _____ happened to my object, but maybe _____ happened instead.").

3. Imagine your object as something else (mountain, football field, ocean, forest).

4. Invite another person to play with you (ask: "What do you see?" or "What do you think our object wants to play?").

Remember to talk with your object, too, and ask it to play with you. Focus on listening for how it wants to play. If you let yourself believe your object can play with you, it *will* share secrets and surprises with you. I promise.

Between

Everything
expands
from edges.

Return yet again to your same small object. You will continue to look closely. Focus on a moment of *Play*—shift your perspective or find something new. Then, focus on a moment of *Stay*—be present with a bit of something you noticed on your object or from your mind.

To practice *Between*, allow synergy and momentum between *Stay* and *Play*. Imagine them in a dance together . . . your very own noticing dance!

Don't worry about how long you focus on either one, maybe 30 seconds of play and 30 seconds of stay, or maybe 1-2 minutes for each. It doesn't matter.

You are striving to notice the space *between*—when you shift from playing to staying and from staying to playing. Bring your attention to this space and notice your mind—*why* and *how* it shifts when it does. Feel when you want to *Stay* and when you want to leave to *Play* anew. Feel

when your mind is leading you and when the noticing itself happens from a place outside of (or expanded from) your mind.

There is a tease to it, maybe some slight tension. There will be lots to notice in your mind and how it wants to control the dance. Keep your focus on allowing your noticing of process—your *noticing-of-noticing*—to emerge.

Don't force anything. Allow things to happen on their own. Simply keep your focus on looking at the object and let your awareness expand. For me, at some point, a layer floats above me and I float above that layer, so I am watching myself look at the object and watching my own noticing-of-noticing. It might emerge differently for you. Whatever happens is a gift. Allow it.

Rest & Reflect

How was your practice of this loop of moments? What did you discover about your one small object? What did you discover about yourself as a noticer?

Did you find anything that you didn't like and wanted to resist or avoid? Wonder about this. Maybe write in a journal or make an audio recording—something that lets you hear yourself reflect.

How do you feel about the one object you spent so much time noticing? Do you feel any sense of attachment? How does this object relate to the other objects you've collected?

Have you connected, applied, or adapted your practice of *Stay* ⟷ *Play* in other areas of your life? Where do you bring a lot of *Play* and where do you easily *Stay*? Have you found ways to bring more *Stay* to your *Play* and more *Play* to your *Stay*?

Before moving on

There is no "proficiency" required before moving on. If you're uncertain about the practice of *Between*, this is not only fine, it's ideal. The more you can practice noticing while you also embrace uncertainty and not-knowing, the deeper your experience will be. In fact, if you feel like you completely understand *Between* and your noticing-of-noticing, take some time to feel into what it means to not-know—let yourself find and allow more space to be present with uncertainty.

Loop Three

Draw · Allow · In-Out · Become

Draw

We draw
to find
more
of what's
there.

You will now practice how to *Draw* as a way to notice. Yes, you are going to draw. You likely have feelings about this that fall somewhere between eager and reluctant. You might be on the far end of reluctant and think: *Yikes, I can't draw. May I skip this part?* All feelings are fine. Notice them. Then let them go. You've got drawing to do.

Pick any of your small objects. Just one. You'll also need a piece of unlined paper and a pencil without an eraser. If you can't find a pencil, a pen will do. If your pencil has an eraser, try to break it off or cover it (if you're extremely disciplined, you can pretend it's not there).

Set a timer for 10 minutes for your first draw-to-notice experience. Each time you practice (you'll want to do this more than once), you might want to increase the amount of time by 2 minutes until you find an amount that works best for you.

Start the timer (move it away from you so you don't watch time as you draw) and begin. Draw the entire time. Draw what you *see* of your object (from sight and/or touch), not what you imagine. Only draw, don't write or label or erase or scribble over anything. This isn't about the drawing product, it's about your noticing. You are drawing in order to notice, to find more in what's there.

If you don't like these parameters, want to change some of them, or if you still want to skip this part, notice this. Anything you think or feel or do is fine. It's all material to notice.

I encourage you to relax, settle in, allow grace, and let yourself draw. Let your object feel your attention. Invite your object to tell and show you more. Open your awareness to how your object is noticing you, too. Delight in this.

Allow

Loosen
out of push,
control,
judge—
open to
what is.

You will now draw to notice again, this time with more attention to your thoughts and feelings as you draw. You may return to the same object or select a different object. Keep all other guidelines the same.

As you draw, bring your awareness to your process. It's a little like the *Between* practice, where you hover above your noticing to witness what your mind is doing. You might notice yourself move between *Play* and *Stay*, but you may also notice other things, like strong feelings (including "boredom" or "not-good-enough"), memories you haven't thought about in a long time, elaborate daydreams, or maybe lists and plans for something related (or seemingly unrelated) to the object.

It doesn't matter what happens in your process as you draw, what matters is that you practice how to *Allow* all of it. Don't judge your process or analyze it. Let it be. If you notice yourself telling a thought or feeling to go away or telling yourself

to "focus" or "get back on track" (e.g., judgment), notice this and allow it, too. Nothing is wrong. When you allow whatever happens, you open yourself to more noticing material.

Try not to write while you draw, but do record some notes about the thoughts-feelings you noticed immediately after your drawing time ends.

If you want an extra challenge, stay with the same object for all of these drawing moments. This will not only reveal layers of challenge (or ease) from looking at the same thing again and again, it also may reveal interesting thoughts-feelings about attachment and holding-on. Plus, the more attention you give an object, the more layers of loveliness it will reveal.

In-Out

As tides,
breath,
reflection
of light,
kneading
bread.

You're ready to go deeper with your draw-to-notice practice. You'll focus on looking *in* to notice your object and allow whatever you find that comes *out*. You notice (in) to wonder (out).

You'll want a separate piece of paper to jot notes as you draw, or you may want to do an audio recording to talk aloud while you draw. Allow yourself to name all of the things that come *out* as you look *in*. Think of yourself as noticing to mine for new threads of thought—joyful, ethical mining for the purpose of wonder.

One of the strands of *In-Out* practice is about the object itself. You notice a hole, you wonder: *Why? Are there more?* You notice a slight bend that before you didn't see, you wonder: *Did that just happen? Does it serve a purpose?* You notice small, printed letters, you wonder: *Is that code? Does it tell when this was manufactured?*

Another strand of *In-Out* practice is about yourself, including your daydreams (*you notice a*

shell and you're on a beach), memories (*a button reminds you of your grandma's sweater*), realistic connections (*it's like the metal thing that's on my curtain*), pretend play (*I think I'll call you Xavier, you seem wise.*), planning/lists (*Oh, we need apples and soap*), and feelings (*Why am I doing this again? Can I be done? Am I doing this wrong?*).

Your practice here is not to notice the shift from noticing the object to noticing other things (like in *Between*). Your practice is to keep going back *in* to find more—more wonderings, connections, dreams, memories, even when you think you have found everything there is to find.

Remember you're not alone. Your object is here, too. Connect deeply with your object. Know that it is noticing and wondering about *you* as you draw.

Become

Let it be a surprise. It's easier (and more beautiful) this way.

Are you ready to jump inside your object? This is what you're about to do. You'll continue to draw as a way to notice. Continue with the same small object. (If you've drawn a few objects, select the one you've noticed the most).

Let yourself forget that I just told you you're going to jump inside your object. You can't practice *Become* from effort. Start with what you already know about drawing to notice. Focus on drawing to find more. Let yourself focus on looking *in*.

Stay with this. Keep looking in and drawing what you find. When you notice thoughts-feelings come out, release them, and don't follow them this time. (Don't write anything down either.) Stay close to your object, looking in, in, in.

Begin to talk with your object. Out loud or in your mind are both fine; objects hear thoughts intended for them the same as spoken words. Let your object talk with you, too. Listen and allow yourself to be even more present with your object.

Now, imagine your pencil marks as your footsteps. You feel yourself on your object as you draw. You feel the smooth, the sharp, the sticky, the cold, the angles. You might pause to rest. You might twirl and fall. You sink (or maybe float) deeper and deeper as you draw.

Let yourself find a space with no separation between *in* or *out*. You are in your object. You *are* your object. You might feel sensations *as* the object. You may feel a tickle from your pencil tip or see a shadow from your hand as if it is cast upon you. You allow yourself to drift into your noticing and become noticing itself. Savor this however it shows up for you. Let it become something uniquely yours.

Rest & Reflect

How do you think and feel about drawing now? Is it different than what you thought-felt before these four moments of practice? Wonder why.

What has drawing taught you about noticing? Has drawing inspired any new questions for you? Did drawing let you find anything new about your object?

Were you able to get inside your object and your noticing (Become)? If you're not sure, how would you describe what happened to you? Did it feel different than your other drawing-to-notice? In what way/s?

Have you noticed anything in your life (besides your objects) differently because of your practice of drawing to notice? Has anything shifted?

Before moving on

You will need an assortment of found objects for the next loop of moments. If you only have one or two objects, perhaps return to *Find-Receive-Shift-Be* until you have met a few more small friends. Or simply look around where you are and gather a few small things (invite them kindly, of course) to join the others. Bring your notes about your *In-Out* wonderings to this next loop, too. You're going to have more opportunities to play with these trails of thought.

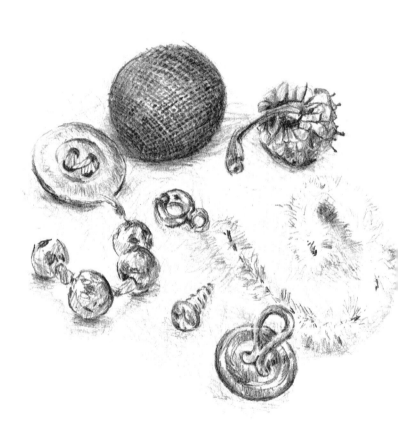

Loop Four

Mingle · Listen · Invite · Ask

Mingle

Juxtapose, overlap, rearrange, build, allow layers of whimsy.

Now you'll gather all of your found objects together. Scoop them up from where they rest and bring them to a cleared-off table or open place on the floor. Let them mingle.

You might push them all together in a pile and then move them around with your hands (like you are spreading flour on a board). Move them fast, move them slow. Watch while you do this or close your eyes. Don't think too much about what you're doing.

Now, let your objects be. Look at them. Sit quietly for as long as you can and let your mind drift between the objects. Notice what you see, what you wonder, and anything else, too. Let your mind *Mingle*.

After this initial "look and be" phase, you may want to write notes (or draw) as you do this next part. Or it may feel better to stay only in your mind.

Start to physically play with your objects. You might want to:

1. Sort your objects by what's same or different.

2. Arrange them from oldest \longleftrightarrow newest or most organic \longleftrightarrow most synthetic.

3. Think about questions you found during your *In-Out* practice, or cluster objects you "know" vs ones that are more mysterious.

4. Write pieces of code or clues you find on your objects to look things up (about mechanics or history).

5. Daydream or pretend-play or write poems.

Keep your objects together for an extended time to come back to again and again (like you'd come back to a 5000-piece puzzle over time). Let yourself delight in anything that happens between you and the objects (and between the objects themselves). Notice what kinds of play you and your objects enjoy. Allow yourself to tap into how you played as a child.

Listen

Trust that
there is
always
something
beautiful to
hear.

Return to the place where your many objects are gathered. You will now shift your noticing play. Your focus now is to *Listen*. Instead of noticing with your mind, let your mind *do* nothing. Open yourself to receive from your objects. Be still and notice their play with each other, what they communicate to each other and you, and the layered ways they seem to experience where they are. You aren't thinking *about* them, you're listening *to* them.

This may seem strange or uncomfortable. That's okay. Notice all of your feelings. Don't make them wrong or right. Keep your focus on your objects. Share your full attention with them and notice how you are finding your way to do this. Build from your practice of *Between* and *In-Out*. This may feel similar. Also notice how subtly and powerfully different it is.

Let yourself accept that this practice is not romantic or make-believe. You are not pretending. Your objects are made of matter, they hold energy,

and they have their own ways to play and express themselves. Give yourself permission to allow this. If your mind wants to disprove this, notice this too. Let yourself jump into the possibility of this moment and fall into the expansiveness of listening to your objects. It's not something to "know."

Your objects will sense if you are listening to them. If they seem quiet, talk with them and tell them what you are practicing. Ask them to help you. Tell them you're interested in learning from them.

Enjoy this. It's quite brilliant to learn what objects notice in each other and what they talk about. Let yourself feel surprise and delight. Your objects will reveal more to you as they feel more embraced by the openness of your listening presence.

Invite

It's quite a marvelous thing to be invited on an adventure.

Your objects have likely told you where they like to rest and who likes to be alone or in a group. Maybe they are in various parts of your home, on your desk or windowsill, in a box or a bowl. You'll now *Invite* your objects to move around, try out new places, and meet new friends.

Start by taking an object or two with you when you leave the house. Ask them: "Who wants to come with me?" The objects who want to join will tell you. Put an object in your pocket or in your bag. Maybe an object can be worn on a necklace or slid between pages in a book.

Also ask your objects if they want to move around your home and try out new places. Maybe they want morning light instead of the setting sun, a noisier room, or a place where they can get to know your pet/s. They might want to spend time outside with a tree or a potted plant. My objects often talk to me when I walk past them, and I sim-

ply pick them up and move them somewhere else for a change of scenery.

All you can do is ask and listen as best as you can. Keep trying new combinations of objects in new locations. Continue to bring an object or two with you as you go out for meetings or groceries or exercise. It might be helpful to keep a few of your objects in a bowl by your front door so you can routinely ask, "Who wants to join me?" as you leave the house and return them to the bowl when you come home.

Be playful and notice what happens. Do your objects communicate more with you now? Are you able to listen to them differently? What do you notice about yourself when you have your objects with you in your pocket? Do your objects tell each other stories about their adventures? What else?

Ask

Surrender,
fall, release
into the
expanse
of a single
question.

For this moment of practice, you'll need some extended quiet time, 15 minutes or so when you can be alone and not focused on anything else. If this isn't possible for you, try to find 2-3 bits of time during your day to practice in small increments.

Select one of your objects. Choose one you have spent quite a lot of time with and is the easiest for you to hear. If you can't decide, ask your objects: "Who wants to help me with something?"

Get comfortable and hold your object in your hand. You might want to set a timer so you can be fully present for the amount of time you've allotted. Go deep inside and find a question that you have about/for yourself, a question you haven't let yourself ask before, a question you have never asked out loud. It might be a question about something that's arisen during your practice of noticing, or maybe it's a question that you've been living inside for much of your life.

Find one question and let yourself ask it to your object. You may ask out loud or in your mind, but make sure you ask it *to* your object. You might also say something like: "Please, will you help me with this question, help me expand my perspective, help me find something new?"

Sit quietly, hold your object, and receive. You don't need to repeat the question or say anything else. Let yourself be still and do nothing. Open yourself to receive wisdom from your object. You are looking from another sense (beyond the five). You'll notice *In-Out* and *Between*, but *Ask* is more expansive. Don't follow or hold anything in your mind. Open up and feel into this noticing. Let your whole being receive what your object has to share with you.

Rest & Reflect

How was this loop of moments for you compared with previous moments? Were these easier, harder, more uncomfortable, less so? Wonder about this.

Has anything shifted in yourself from your practice of *Ask* with your object? How was your experience of receiving in this way?

Have you talked with others about your noticing of objects yet? If you have, how did you describe your practice? What do you notice about how you practice this yourself vs how you describe it to others? If you haven't shared with others, wonder why.

Have you lost any of your objects in this process? Has anyone taken or used one of your objects for their own purpose/s? Did you find any thoughts-feelings about this?

Before moving on

As long as you have practiced each of the moments of this book so far with the best of your intentions, you are fine to move on, no matter what happened in your practice. You may want to practice *Ask* a few times if you found it difficult to receive wisdom from your object in this way. In the next loop of moments, you will practice deeper noticing that builds on your practice of *Ask*.

Loop Five

Unknow · Release · Give · Expand

Unknow

Let go of the holding of names, drift or fall, into something else.

Return to one object with which you've spent significant time, one that you know quite a lot about, maybe your favorite one. Have some paper and a pencil near in case you want to draw or write. Clear away everything else. Set a timer if you'd like.

You will now notice in order to *Unknow* your object. Your focus is to not-know it, to unravel all that you think you know about it, to release all of your past noticings and wonderings about this small object in your hand.

You might be thinking: *What on earth does this mean? How can I unknow what I clearly see and remember?* Don't think too hard about this or get bogged down in semantics. Just say to your object: "I am going to *un*know you. Let's not-know each other." Your open-hearted intention to unknow your object is enough.

Reflect back to your practice of *Play*, *In-Out*, and *Listen*. You might begin with trying one or more of these moments as a way to drift into unknowing. That said, to *Unknow* is more than

these moments, or maybe it's less. Either way, it's different than what you've practiced before. Let it evolve for you in whatever way it does.

If you get stuck, say out loud: "I know nothing." If your mind sees something specific in/on your object and your mind names/remembers something about it, let the thought of what is "known" unravel (imagine pulling a piece of yarn to unravel a scarf).

You might find that drawing or writing helps. You may try to talk to your object. Or maybe you'll need to sit still and stare at your object in order for your mind to release what it thinks it knows. Remember, you're not trying to find more or see something new, you are letting yourself not-know anything about your object. Bask in a full-on embrace of wonder.

Release

Beyond the
edges is
the empty
space . . .
where we
find the
unlimited.

This moment will grow from whatever happened with your *Unknow* practice. Stay with the same object. You will now go deeper into a practice to *Release* what your mind might be doing.

Tell your object what you're practicing and ask for help. Maybe say something like, "Please help me continue to unknow you and help me unknow myself, too."

Start with a focus on your object and let yourself move into whatever space helps you unknow it. Then, bring your awareness to your mind (and feelings) as you practice. Continue until you notice something that stands out (a question, idea, memory, emotion).

Now shift your focus to this piece of your thinking-feeling. Allow yourself to unravel this like you did with your object "knowing" (like pulling yarn). Then, go deeper. Focus on the space around what you are noticing, the empty (negative) space.

Notice the edges of your thought-feeling and the expanse of nothingness around it. Breathe into this space. Notice.

If you notice yourself having thoughts and feelings about this practice (you feel like you're doing it "wrong," you're confused, sleepy, or bored), do this *Release* practice on those feelings, too. Bring your awareness to them (one at a time), find the edges and space around them, breathe into this negative space, and notice what happens.

Keep returning to your object to unknow it. Each time you notice a thought-feeling, return to your *Release* practice. You might go back and forth a lot or you might find that as you release more, you're able to stay longer with unknowing your object. You might also find yourself staying inside your *Release* practice for long stretches of time. There is no right way. There's not even an ideal way. It's your practice.

Give

When we give, we receive and when we receive, we give.

By now you likely find yourself with many small found objects. They may live in various places in your home. You might continue to move them around and take them on outings. Now you will practice how to *Give* them to others.

I'm not going to lie, this can be hard to do. It's easy to grow attachment to your objects, especially the objects who have helped you discover new layers of yourself. This is okay. You don't need to give them all away. And there are many ways to give. As with everything, we'll start small.

Ask your objects if anyone wants to try out new kinds of homes. They'll tell you if they want to stay or if they're okay to leave. If you feel like you absolutely can't part with an object, it's likely because that object has more to teach you (this is the story I tell myself when I don't want to part with an object).

Here are a few things to try:

1. Trade an object with someone else (maybe forever or for a week).

2. Give an object to nature (in trees and nooks outside when you go on walks; it's fun to check on them to see if they're still there or were "found" by someone else).

3. Ask someone to hide your objects in your own home/yard (objects love this; it's like hide and seek, and you can find them again!).

4. Give an object to your pet or child/ren to use in their play (you may ask for visiting rights).

5. Give an object to a friend as a gift (tell them why the object matters to you and why you want them to have it).

Notice all the ways you give and share your objects. Notice what shifts in you when you do this. Remember to ask your objects how they feel and what they want in this process, too.

Expand

Infinity lives
in small
things.

You have come far in your noticing. Now is a moment for you to sink into the depth of your practice while you *Expand* into the infinity of what is (or might be) small.

For this moment, I invite you to let yourself fully accept this idea as true: *Everything small is big and everything big is small.*

Let's start with something small. Select one of your objects. Hold it in your hand. Notice it from the fullness of all you've practiced (any of the previous moments). Allow everything—zoom in, grow, shift, unravel, reform, collapse, evolve, become. Allow what you notice to expand into what you notice of yourself, your home/life, earth, beyond. Don't try to focus on anything in particular or separate the object from yourself. Let your one small object expand as the immensity that it is.

Now, let's start big. Select an idea or feeling that seems too enormous to wrap your mind around,

something too big to understand or know, maybe it's full of daunting struggle or perhaps it feels like your only point of grace. Hold this one big thing in your attention. Be with it and breathe. Let yourself see its form (however it appears for you). Stay with it, let yourself notice the fullness of what it is (and the fullness of your thoughts and feelings).

See the whole of its expanse. Feel awe. Smile. Be curious. Then, reach out to it. Touch it. Pick it up and hold it in the palm of your hand. Stay here like this, holding its expanse as small, for as long as you can.

Expand *into* it. Look at it as if it is a single button. Talk to it like it is your favorite stone. Ask it what it needs from you. Listen. Connect. Be. Let this expand *you* into the immensity of yourself, beyond big or small—as love.

Rest & Reflect

How do you feel? Think back to how you felt
after the first few moments of practice. Has
anything shifted in how you feel about noticing?
About yourself? What, why, how?

Have you found
any connections
or applications
with your practice
of unknowing?
What aspects of
your life would
you like to *Unknow*
and embrace with
deeper wonder?

What has happened
through your practice of
Give? If you gave an object
away without any expecta-
tions of its return, how did
that feel? Did your object
communicate anything to
you during the transition?
If you traded an object or
shared it for a set time, how
did you and your object/s
feel about this?

Has anything shifted in your embrace of ideas, questions, or situations that you might define as too big to wrap your mind around? Have you noticed yourself practicing *Expand* in ways that are surprising?

Before moving on

Take time to honor yourself and appreciate your commitment to practice *How to Notice*. Noticing is a small thing. It's also everything. Let yourself soak this in and savor the gift you gave yourself. This practice of noticing is now yours. Keep it with you and continue to embody noticing throughout your life. May it bring you expansive delight.

It is

The snails, the bees,
the squirrels, and the moss.
The stone in your hand

and the ripple upon ripple
on top of the clear lake
when you skip your stone
as an offering.

You watch the circles grow
until they disappear
and you wonder

about sound and labyrinths
and what the wind knows
of a mandala's prayer.

The geese overhead,
a cuddle of frogs,
the in and out of breath,

the curve of a turtle's shell
holding a piece of light.

EXTENDING YOUR PRACTICE

Noticing is a slow journey that happens in layers over time.

Where you go next on your journey is up to you. I invite you to continue to play with noticing in new ways and in various contexts so you may connect, adapt, and transform your noticing for your overall well-being.

You may want to return to a moment (or whole loop) of practice in this book to deepen your experience with noticing. Nothing in this book is about "mastery." If you practice something once (or ten or twenty times), you don't "know" it. You'll discover new connections, find new questions, deepen your reflections, but you'll never be "done" learning how to notice.

Noticing is an infinitely abundant gift.

Reflection questions

What brought you to pick up this book and practice how to notice? Do you remember what you thought about noticing then? What do you think about noticing now?

What shifts have you noticed in your life that may have shown up, in part, because of your noticing practice? Where in your life would you like to experience a shift towards something else?

Are some moments of noticing practice clear and distinct (you can readily name and explain them)? Do some moments overlap, blend, or blur (you combine them, practice them alongside each other, or can't explain one without another)? Have you forgotten (or ignored) some moments entirely?

Have you found yourself returning to some moments of practice again and again? Why do you think this is? Where and when do you practice these in your day?

Has any aspect of your practice become like a habit for you, as if it's a way of being rather than something you think about to deliberately practice? Would you like one (or more) of the moments to become a way of being? Why?

Who (other than your objects) do you talk to about your noticing practice? How do you explain your practice? Have you invited others to join you in noticing?

What other practices in your life most closely connect to, and overlap with, your noticing practice?

Where are the places where you (could) most easily incorporate noticing?

———————

Take your time with each question and come back to this list every so often. Maybe one resonates with you now. Maybe another will resonate with you a month from now. Trust yourself and trust in noticing. Remember that noticing itself has energy. It's always present and available to guide us to see/find/be exactly what we need in a moment.

A few suggestions

Keep a noticing journal. Record anything you notice during the day: object, moment, shadow, sound, memory, daydream, feeling, worry, surprise, doubt. Your practice of recording what you notice will keep your awareness for noticing open and alert.

———————

Continue to talk with objects (out loud or in your mind). The aliveness of the universe expands through our engagement with it. Your embrace of the aliveness of objects is only a beginning. Don't drift back into over-thinking about what you can't see or "know." Trust that there's always more to notice. Delight. Have fun. Listen to your objects. They want to play!

Learn more about noticing. You may be interested in one of the books listed in Further Reading. Maybe an idea described in Nuances of Noticing or Applications of Noticing will pique your interest and inspire some reflection or research or dreaming.

Let yourself rest and relax. Every day. Through relaxation, you'll go deeper into your noticing practice, sense into inner wisdoms, and become more aligned with who you are.

Regardless of how you continue with your noticing practice, allow yourself to embrace it with lightness and ease. Let yourself discover each morsel of your continued process as if you are finding a small object on the ground.

Allow surprise. Delight in everything you find. Each glimpse of understanding and drift of wonder is a gift.

NUANCES OF NOTICING

Noticing and looking

Noticing often includes looking, yet it is much more than looking, and certainly more than looking with eyesight. Often, looking is about looking *at* or *for* something specific. Noticing sometimes includes looking at/for something, but noticing moves into, out of, and beyond looking. If you jump to looking too soon, over-emphasize it, or narrowly define it, you'll miss the nuances of how to look in ways that weave playfully within an expanse of noticing.

Noticing and observation

Observation is an important layer of noticing, especially when the observation is for the purpose of accepting what is and/or describing more of what's observed. In this way, observation is an extended space for being present to what is (observed as) there. However, observation with a lens for interpretation or evaluation, while perhaps useful in some contexts, prevents deeper layers of noticing. In a practice of noticing, when you observe your mind tell stories or judge things, simply allow these thoughts, let them go, and continue noticing.

Noticing and metacognition

There are elements of a noticing practice that may seem like metacognition (thinking about thinking). Noticing of noticing, for example, is a parallel practice. That said, noticing is more multidimen-

sional than thinking and invites an expanded space for witnessing all that we are, and all we are connected to, in our being.

Noticing and drawing

In a practice of noticing, we draw to notice. Drawing is a method *for* noticing. There are other ways to practice drawing, of course, including noticing to draw. Many visual artists have their own practices to notice *for* drawing. For the practice shared here, the drawing product isn't what's important, it's the process of drawing (the act of pencil on paper) that allows us to find more in an object, and in our ways of seeing, knowing, unknowing, and being with our noticing.

Noticing and meditation

There are many connections between an experience of noticing and an experience of meditation. In a way, noticing is a meditation practice. It's also not a meditation practice. Noticing isn't about being one thing for one purpose. It can be a meditation and other things, too. Noticing is playful, adaptive, and transformative. Whatever way you think of it, how you experience and *re*experience it—it's all fine. It's *your* practice of noticing and however (and wherever) you want to integrate it into your life is perfect.

Noticing and consciousness

If you are someone who studies consciousness and brings awareness to your ways of being within various consciousness fields, this practice of noticing will likely resonate with you in that space. If you are someone who doesn't think about consciousness, it will resonate with you in another way

(through another kind of vocabulary or frame). There are no pre-conditions of "understanding" or "experience" or "vocabulary" in order to grow a practice of noticing.

Noticing and attention

As you develop your noticing practice, you will notice shifts in what you give attention to and how you give your attention. You may also grow a deeper understanding for what it means to hold something with/in your attention. Noticing allows more nuance and intention with attention. Noticing also deepens awareness for subtle whimsy, surprise, drift, dream, and beingness that grows from deep attention. Deep attention is one of the beautiful gifts of noticing.

APPLICATIONS OF NOTICING

Noticing as play and rigor

There's no dichotomy between play and rigor. The essence of play *is* rigor and the essence of rigor *is* play. A practice of noticing allows you to explore this overlap and wonder about the world through the rigorous play, and playful rigor, of noticing. Apply this to everything you do for more joy, depth of thinking, nuance, and overall lightness of being: Bring your attention to something you think you know and let yourself not-know it; notice your mind fluttering away from an idea and nudge it to stay a bit longer; let yourself drift and shift your perspective to see something else; delight to find ways to be wrong; talk to energy and ideas and let them guide you; listen.

Noticing as mindfulness

There are many ways to practice mindfulness as you bring awareness to the present moment, accept

where you are, and allow all feelings-thoughts. A practice of noticing, especially a foundational practice for noticing small objects, supports practices of mindfulness in concrete, accessible, everyday ways. Apply noticing anywhere in your life to help you slow down, connect deeply with others, expand your awareness, and appreciate small things all around you.

Noticing as prayer

Silence and solitude, connection to energy and other beings, introspection and reflection, acceptance of self and what is, stillness to receive, everything as light. Noticing opens space for all of this and more. Each moment of noticing practice is a prayer of sorts, an invocation, a way to speak-into-being what is ever better, ever more. So it is.

Noticing as teaching

Noticing is a teacher we all need and a teacher we all have. We only need to decide to connect with noticing as our teacher (and let noticing guide our teaching). Noticing allows us to see more of what's there in learners, learning, and our teaching. Noticing invites us to be present to the full range of students' dispositions and understandings, beyond the outdated notion of "noticing" for assessment and evaluation, into the realms of holistic descriptive noticing for deeper understanding and attuned listening for what matters most to learners and learning. Teaching as a practice of noticing invites curriculum as a dialogic process, inspires layered production of knowledges (instead of "known" inputs), and creates spaces for everyone to be fully human while learning, teaching, and being.

Noticing as leadership

Noticing allows leaders to see more of what's there, and see more in the empty, open spaces between what's there. While each separate noticing practice is important for leadership (especially playfulness and unknowing), it's the holistic embrace of noticing that will most significantly shift leadership impact. Leadership that focuses to connect and listen to all elements of an organization, business, or context as if each piece (client, member, product, idea, etc.) is a brilliant small stone full of expansiveness—this is an expansive leadership that knows how to notice for, find, and lead into infinite possibilities.

Noticing as well-being

Noticing is based in, and allows for, an expanse of trust. Trust that we are whole and enough. Trust that we will receive what we need when we're open to it. Trust that there is beauty everywhere. Trust that everything is possible. Yet, often these stay only as ideas in our minds, and in our minds, they aren't alive in practice or available for open-hearted, receptive trust. They're just thoughts. The way to experience trust of all that is possible is to practice it multidimensionally (body-mind-spirit-more). Everyday noticing of ordinary small things allows you to develop a habit of practice for well-being without thinking about it too much. When you learn to be present with everyday things, savor your noticing of them, allow and release what often clutters your mind, you create your well-being from the inside out.

Noticing as activism

Noticing is an action towards something possible that is not yet visible or understood. Noticing allows what is—not passively or with avoidance, but actively by allowing what is present and inviting an expanse of space around its edges. The more we notice what is there, the more we can find in what's not there and what might be created there. Noticing opens space for new energy and new possibilities. It does not react against what is present because reacting only expands what's there. Through awareness and clear vision, without any energy of reaction, noticing invites opportunities for radical change and transformation: connection, listening, playful reinvention, shifts of perspective, depth of understanding, healing, wholeness, and love.

Noticing as love

Noticing is a practice of love. Noticing *is* love. At its core, noticing is full acceptance of yourself and others and everything around you as perfectly whole. Unconditional. You are me and I am you. Ubuntu. We are light, love.

FURTHER READING

Bachelard, Gaston. *The Poetics of Space: The Classic Look at How We Experience Intimate Spaces.* Beacon Press, 1994. Translation, The Orion Press, 1964. Original, Presses Universitaires de France, 1958.

Bailey, Elisabeth Tova. *The Sound of a Wild Snail Eating.* Algonquin Books of Chapel Hill, Workman, 2010.

Baylor, Byrd. *The Other Way to Listen.* Simon & Schuster, 1978.

Dillard, Annie. *Teaching a Stone to Talk: Expeditions and Encounters.* Harper & Row, 1982.

Gay, Ross. *The Book of Delights: Essays.* Algonquin Books of Chapel Hill, Workman, 2019.

Giovanni, Nikki. *Bicycles: Love Poems*. HarperCollins, 2009.

Hogan, Linda. *Dwellings: A Spiritual History of the Living World*. Norton & Co., 1995.

Horowitz, Alexandra. *On Looking: A Walker's Guide to the Art of Observation*. Scribner, Simon & Schuster, 2013.

Kimmerer, Robin Wall. *Gathering Moss: A Natural and Cultural History of Mosses*. Oregon State University Press, 2003.

Kohl, Judith, and Herbert. *The View from the Oak*. Sierra Club Books, Charles Scribner's Sons, 1977.

Montgomery, Sy. *The Soul of an Octopus: A Surprising Exploration into the Wonder of Consciousness*. Simon & Schuster, 2015.

Neruda, Pablo. *The Book of Questions*. Copper Canyon Press, 1991. Translated. Original, 1974.

Stanley, Tracee. *Radiant Rest: Yoga Nidra for Deep Relaxation & Awakened Clarity*. Shambala Publications, 2021.

Tishman, Shari. *Slow Looking: The Art and Practice of Learning Through Observation*. Routledge, 2018.

von Uexküll, Jakob. *A Foray into the Worlds of Animals and Humans: With a Theory of Meaning*. University of Minnesota Press, 2010. Originally published in German, 1934.

Wohlleben, Peter. *The Hidden Life of Trees: What They Feel, How They Communicate*. Greystone Books, 2015.

GRATITUDE

The expanse of gratitude I feel for this book is beyond measure.

It emerged in a small moment as a small idea. I remember saying "hello" and knowing from deep inside me that this was something to follow, that this would be a book with something beautiful to teach me. Just as objects are alive, so too are ideas. The practice of writing this book was itself a practice of noticing—full of play, not-knowing, and trust. Throughout the process I was held, accepted, and guided from spirit through mind to pencil on paper.

To the many friends in my life, near and far, who nurture and love me, who listen patiently when I talk endlessly about yet another small object or idea . . . thank you. To my friends and colleagues who read versions of this manuscript and gave feedback, who tried out the noticing moments and shared their stories about what happened . . .

thank you. To my many teachers and mentors (in person and through books) who inspire and nudge me . . . thank you. To all the creatures of the world who show me how to love and not-know, and to the plants and soils who share their ancient wisdom . . . thank you.

I wrote this book in 2020, a time when I was embraced by deep solitude and silence, when my primary connections were with ideas, when I learned to anchor myself in the calm of my attic studio with expansive attention. I am grateful for this time and for all that I can't know or understand . . . thank you.

This book is a wish of love and light for all who read it, share it, connect with it, wonder about it, or hold it in their hands. May it be part of our collective reimagining as we live into a future of connection, delight, deep attention, healing, and wholeness.

All that's possible can be found in a button.

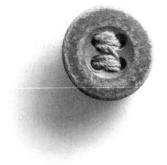

Made in United States
Orlando, FL
08 November 2024

53624795R00078